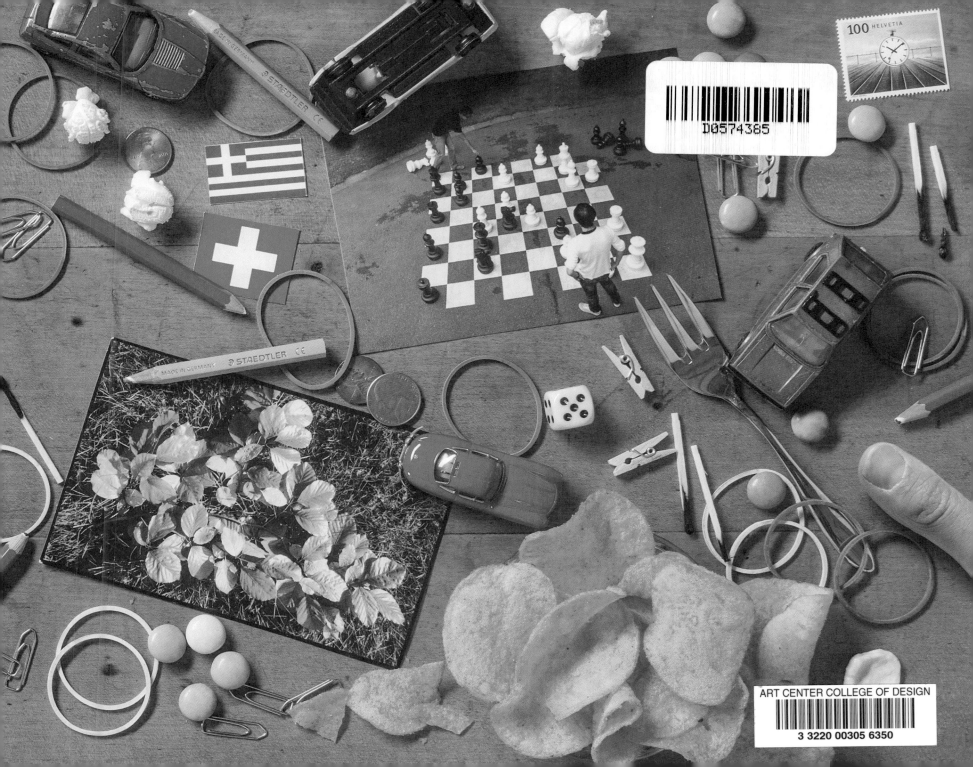

MADE IN GERMANY  STAEDTLER  CE

MADE IN GERMANY  STAEDTLER  CE

# THE ART OF CLEAN UP

# THE ART OF
# CLEAN UP

## LIFE MADE NEAT AND TIDY

URSUS WEHRLI

PHOTOGRAPHS BY
GERI BORN AND DANIEL SPEHR

**CHRONICLE BOOKS**

SAN FRANCISCO

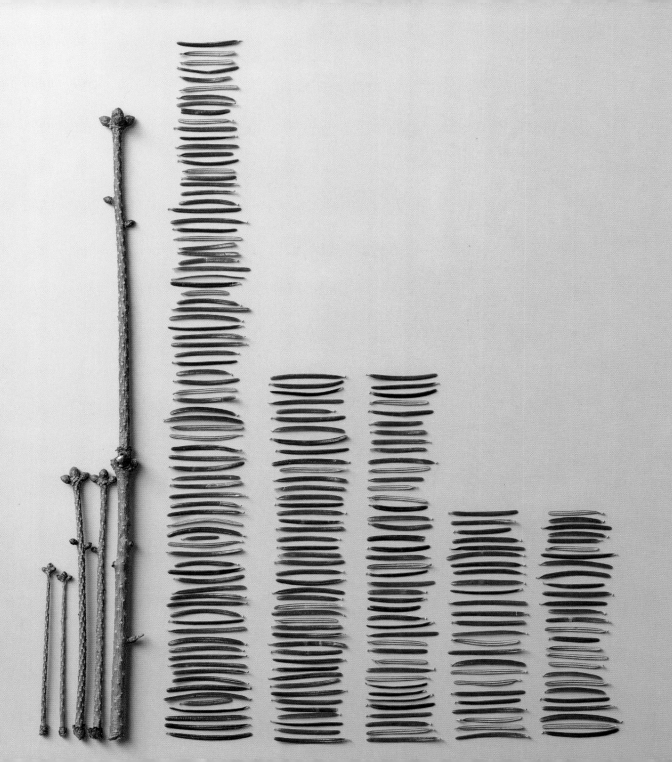

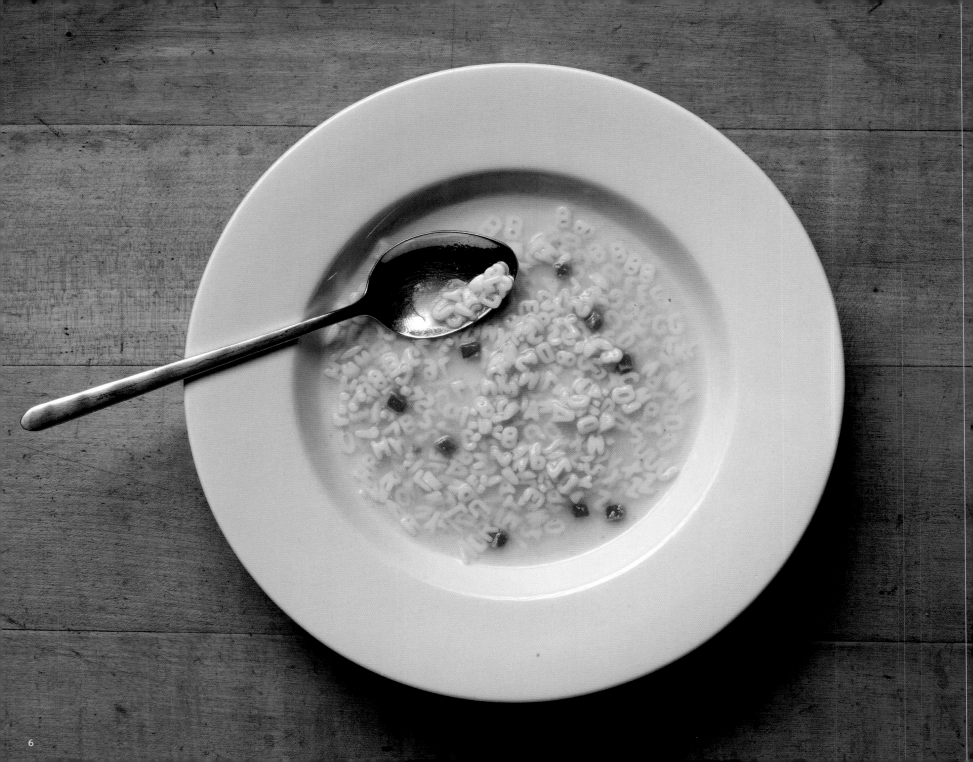

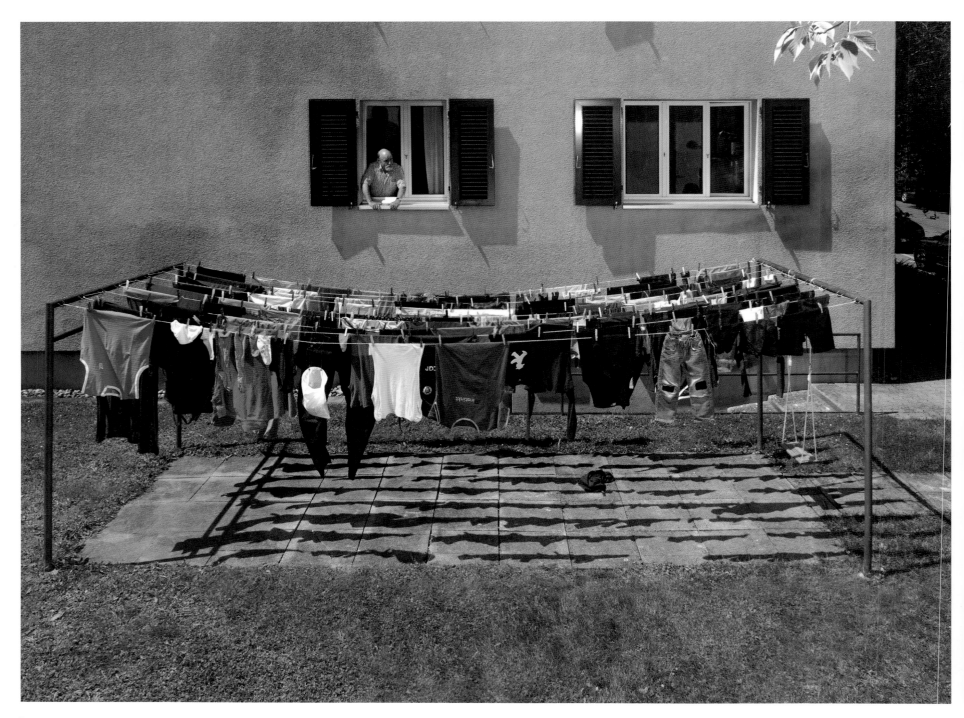

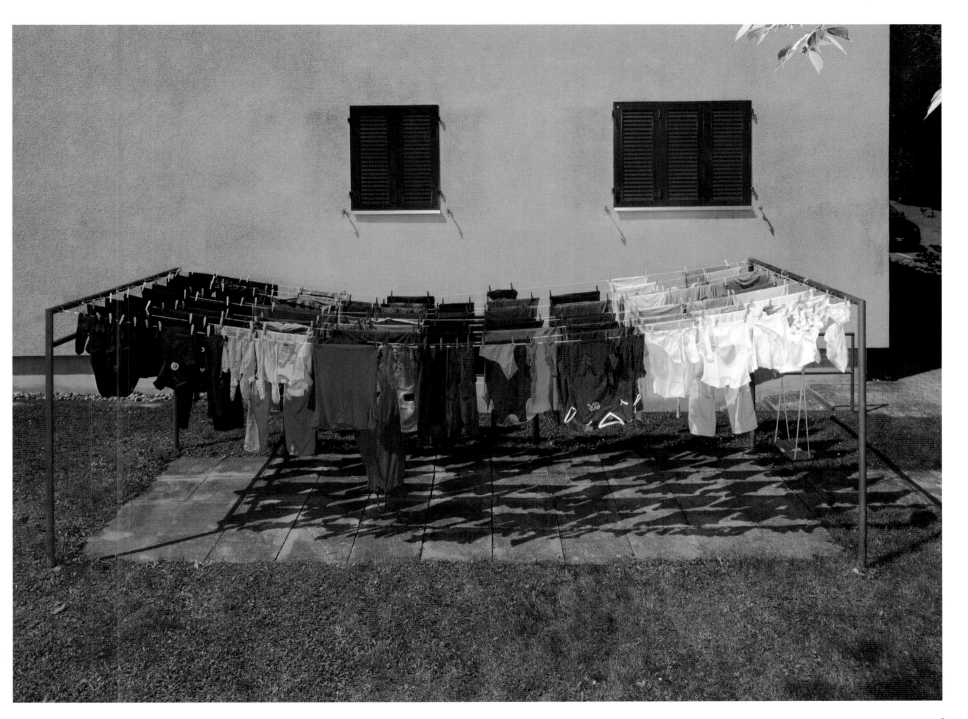

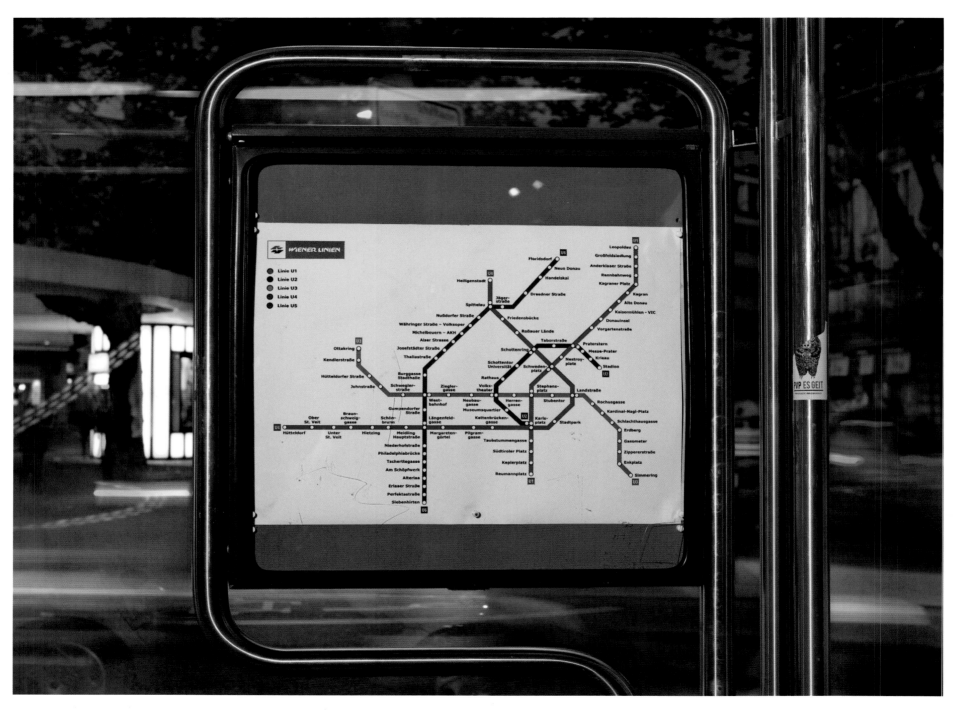

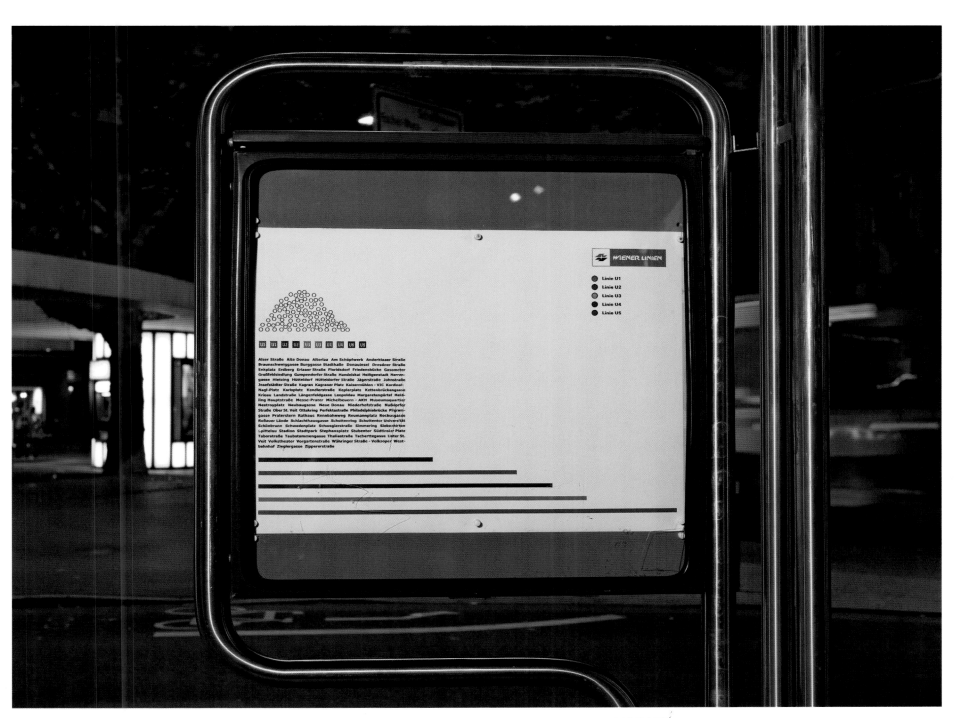

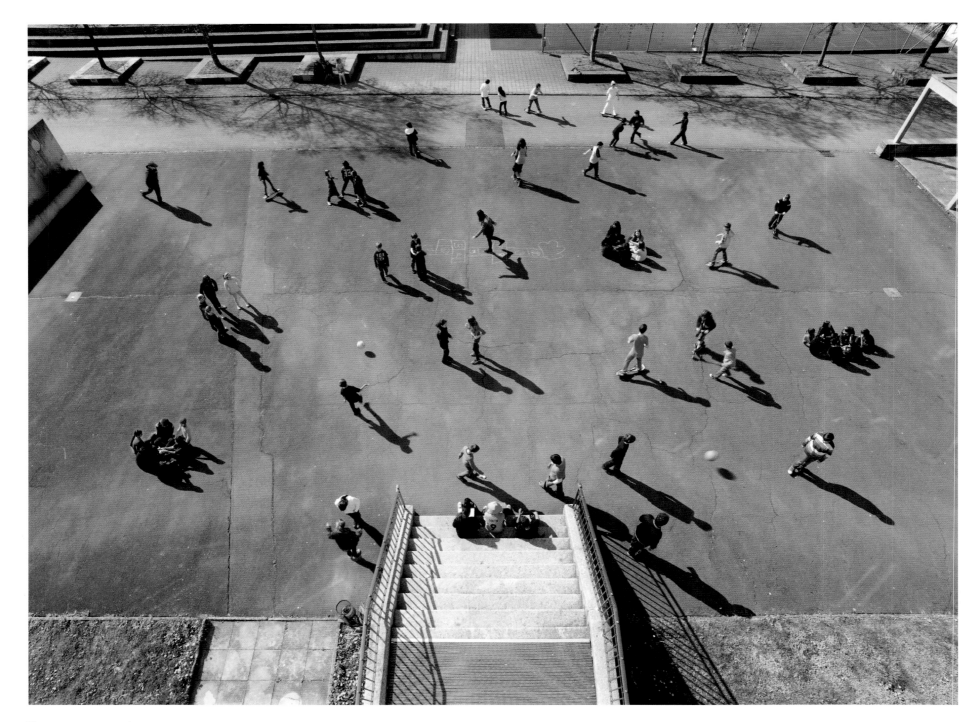

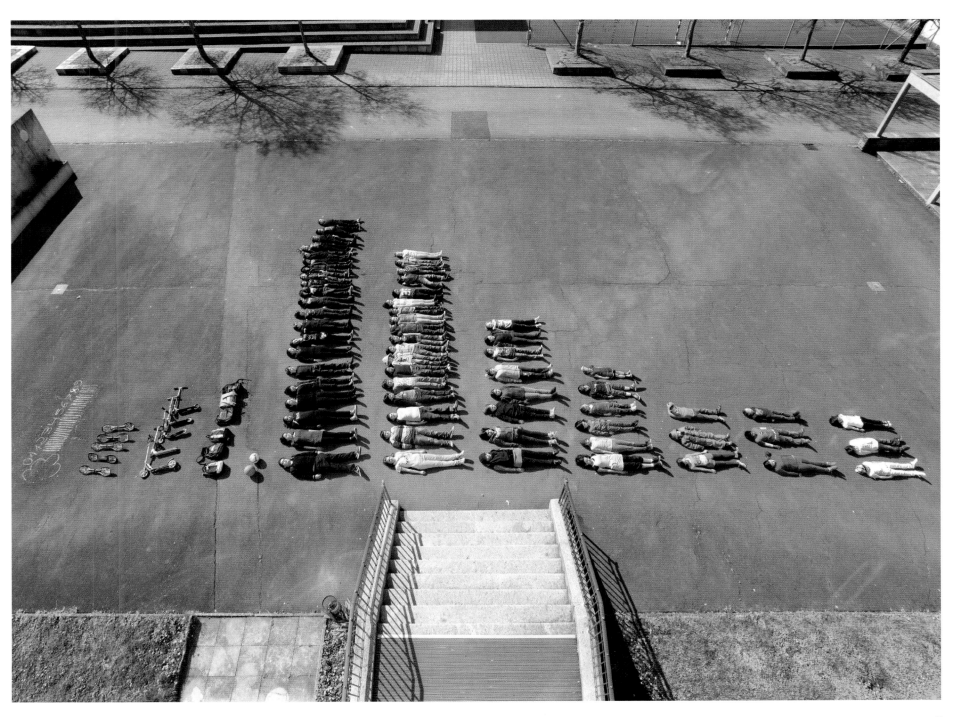

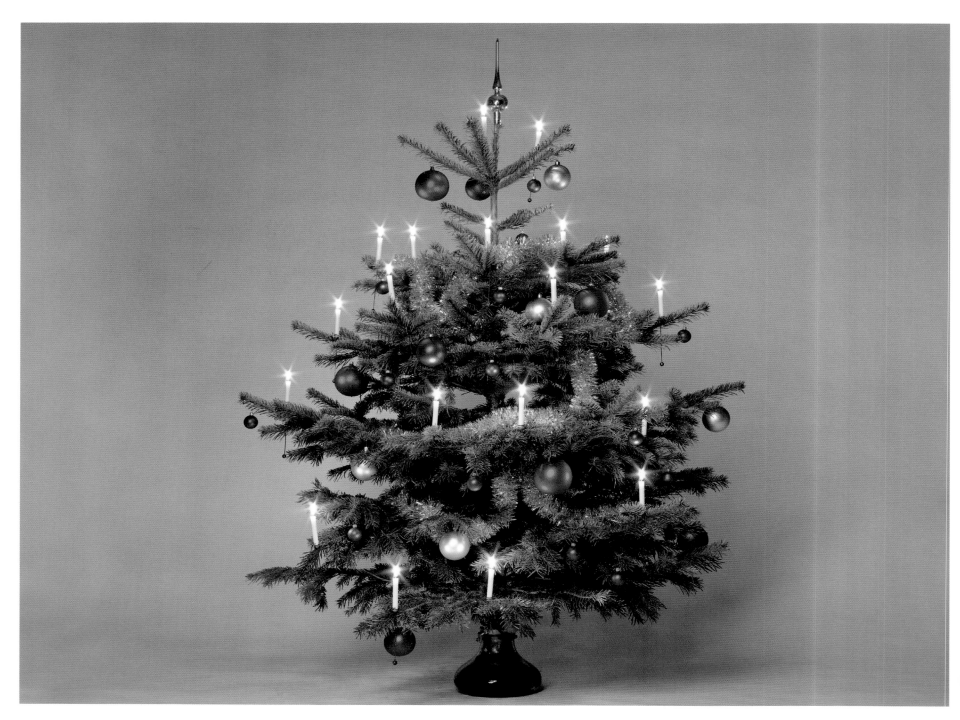

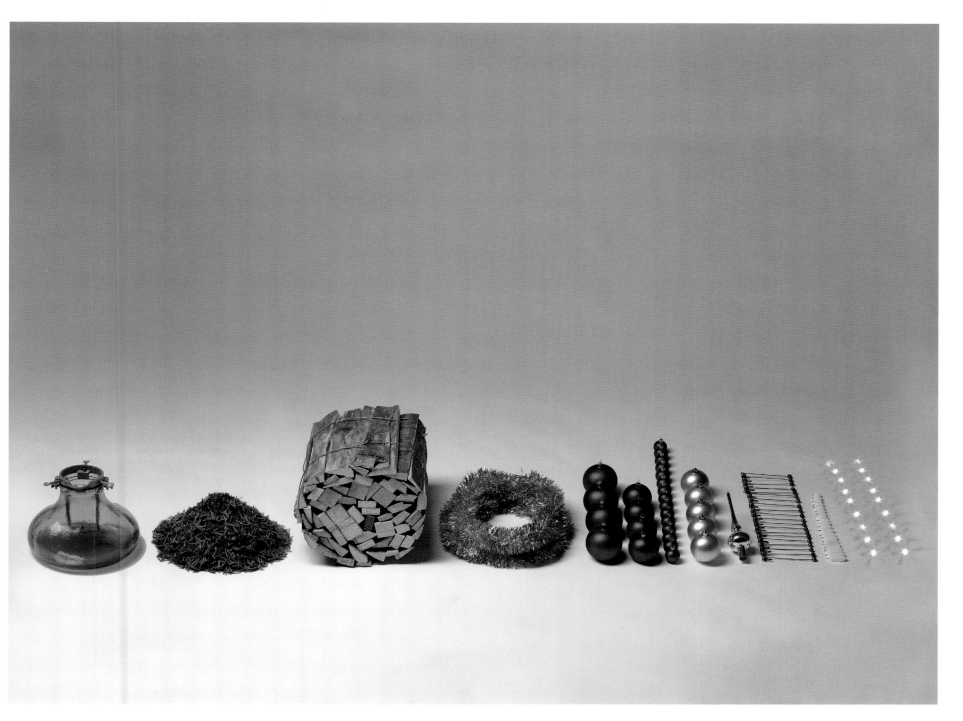

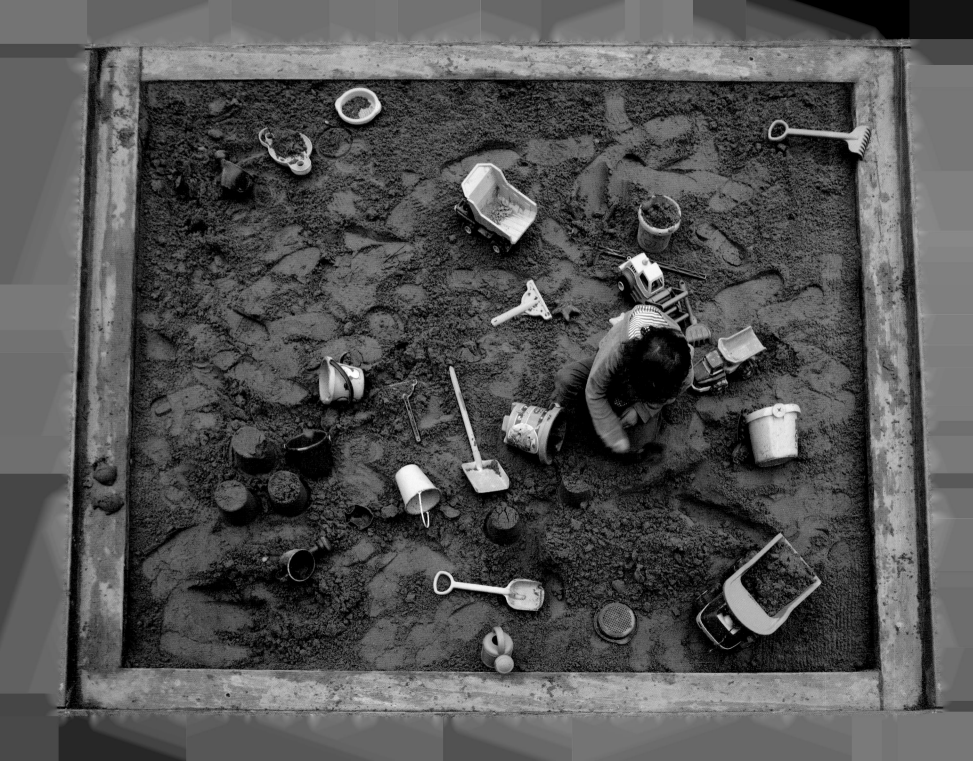

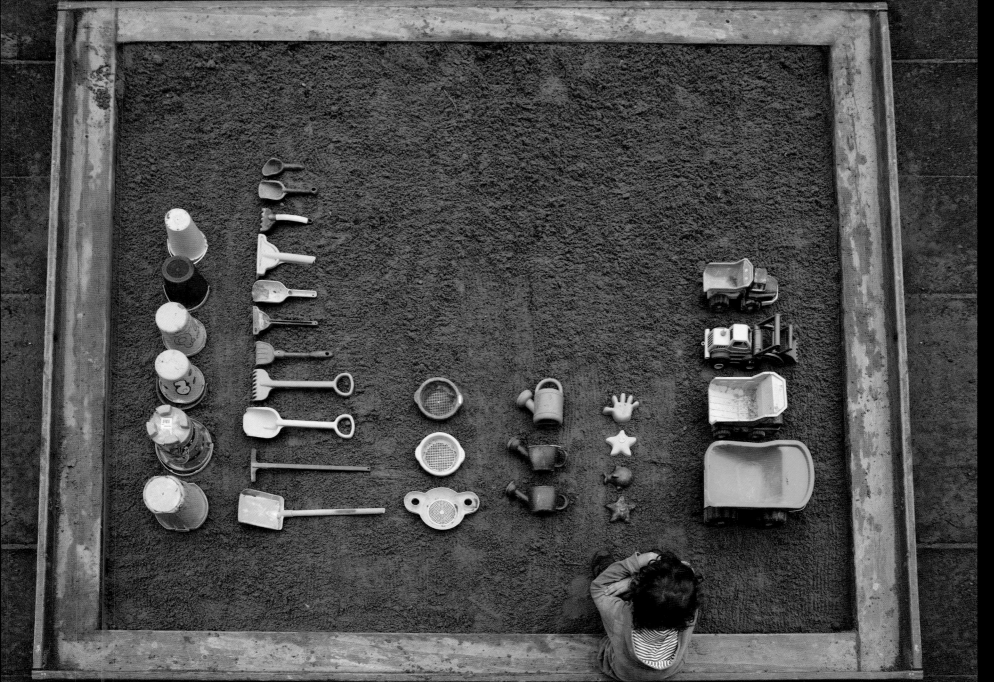

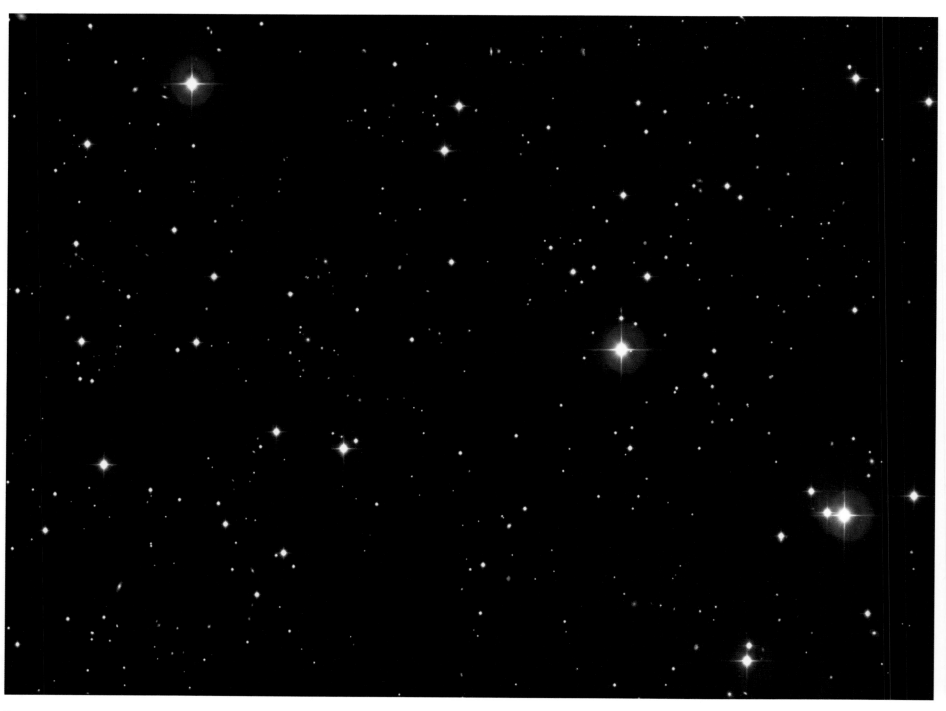

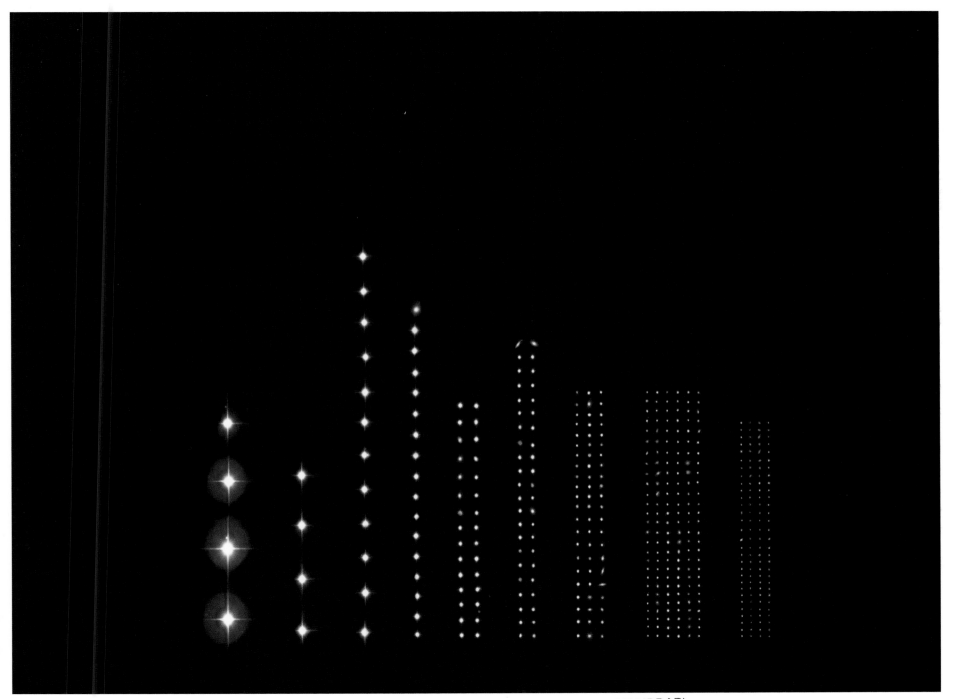

19

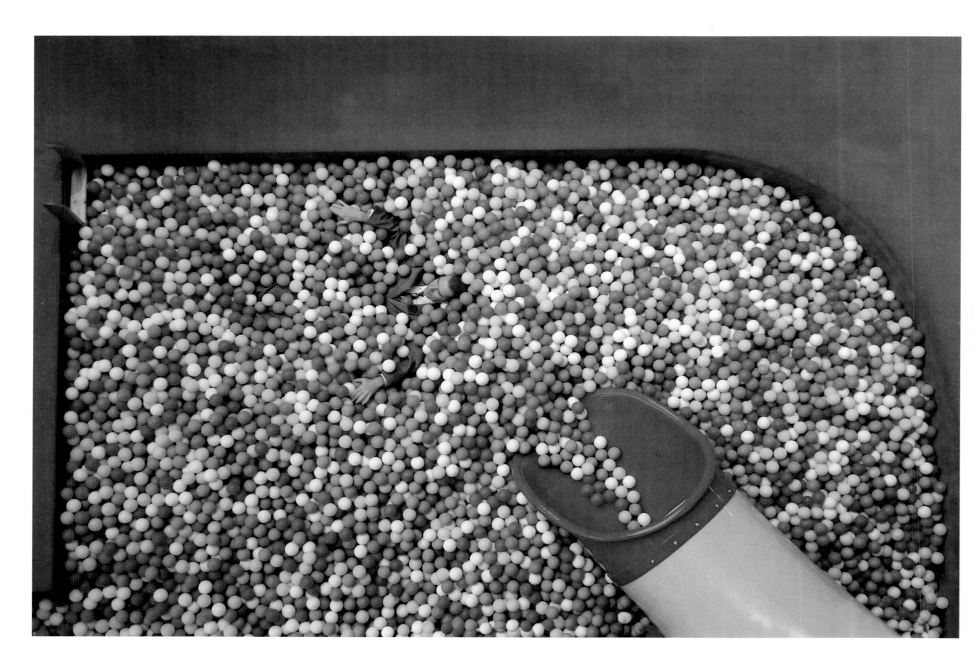

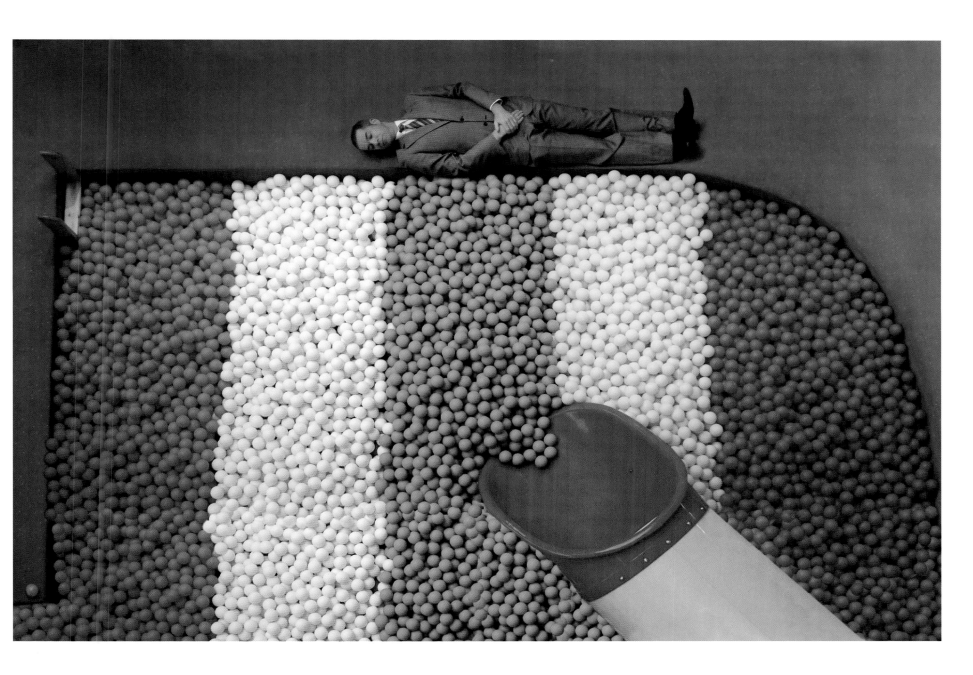

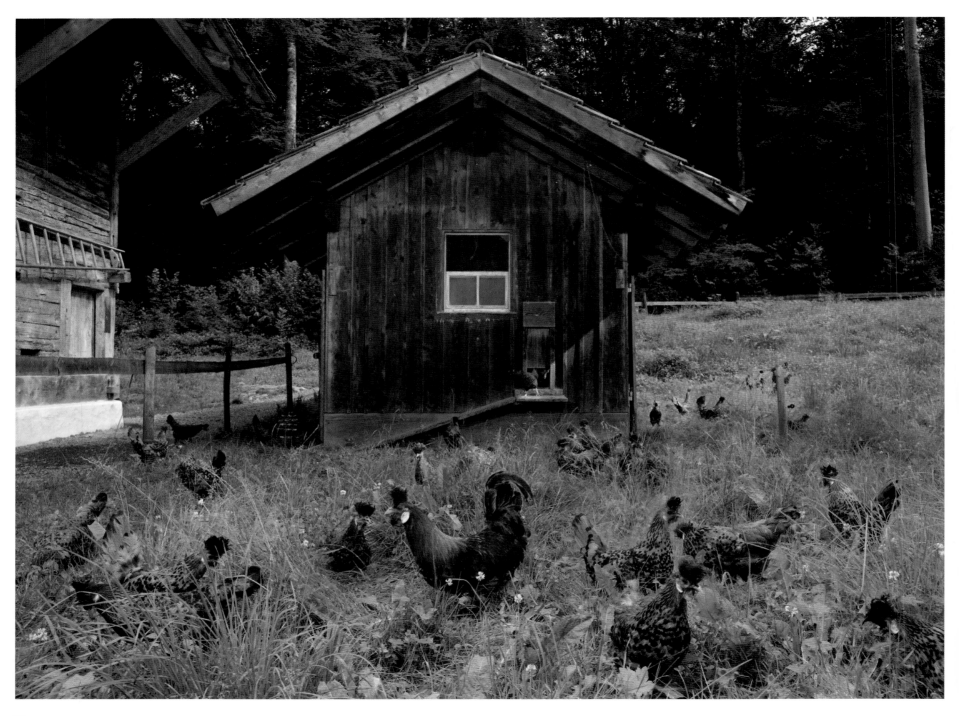

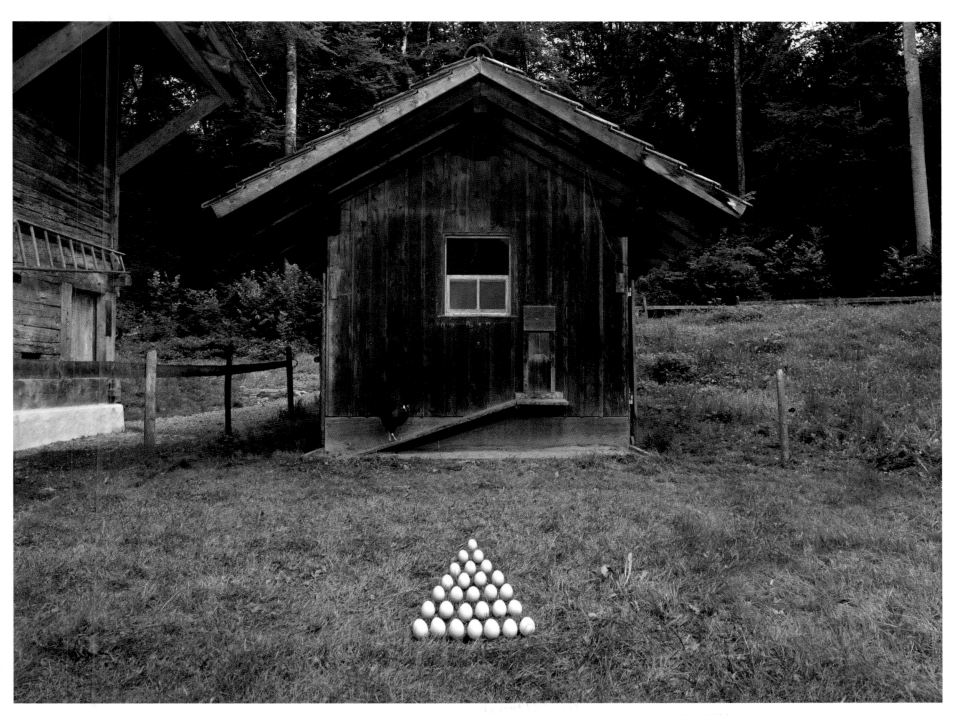

23

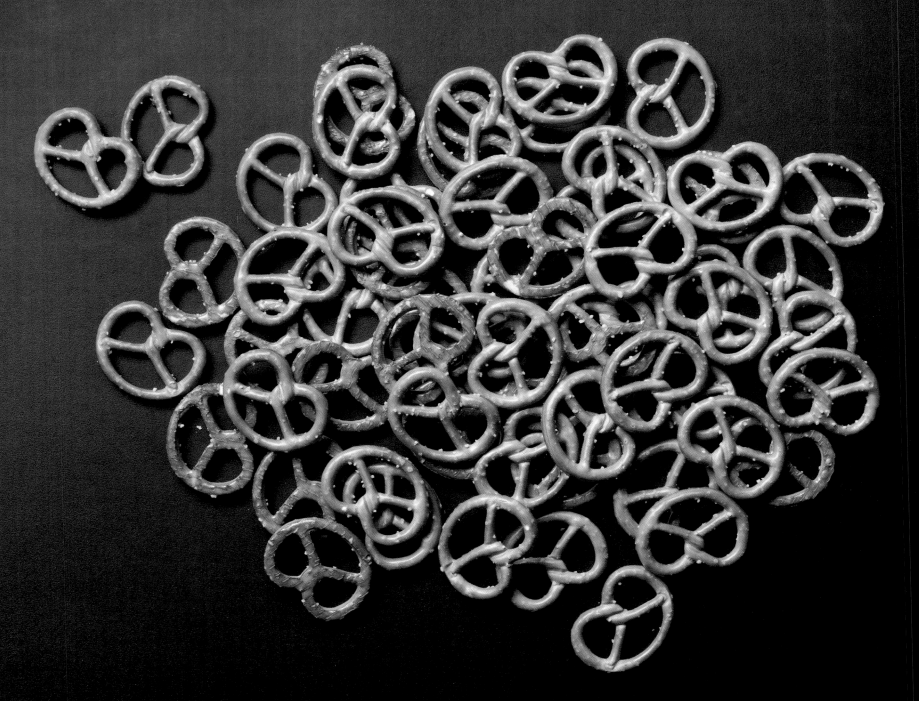

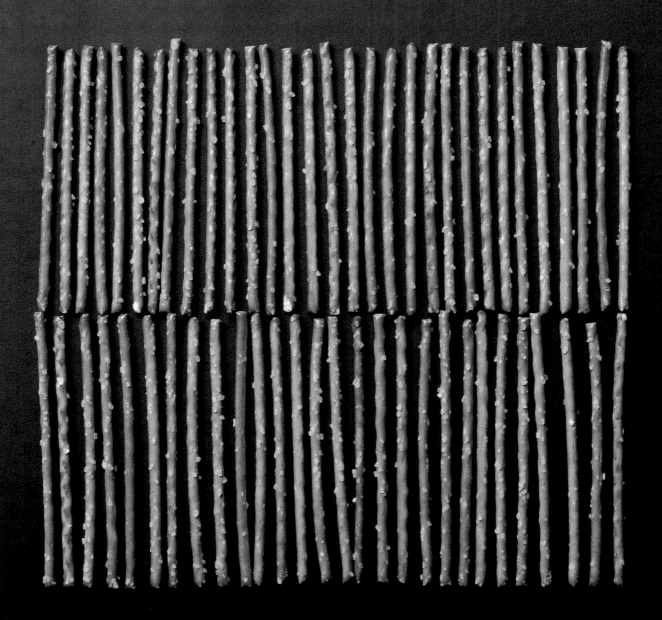

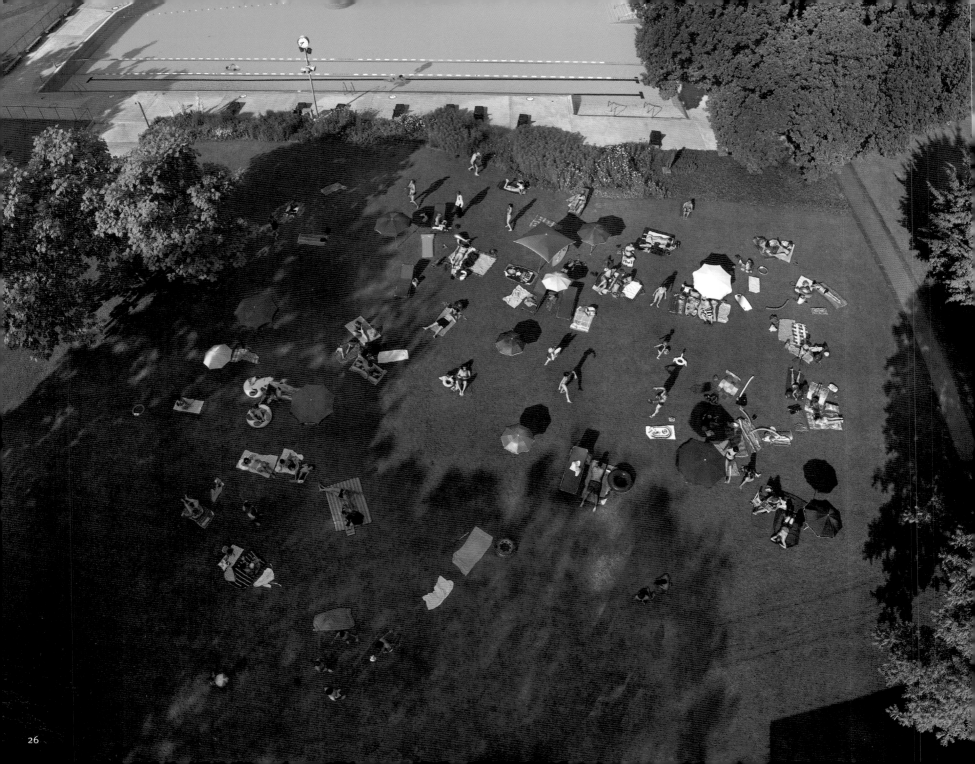

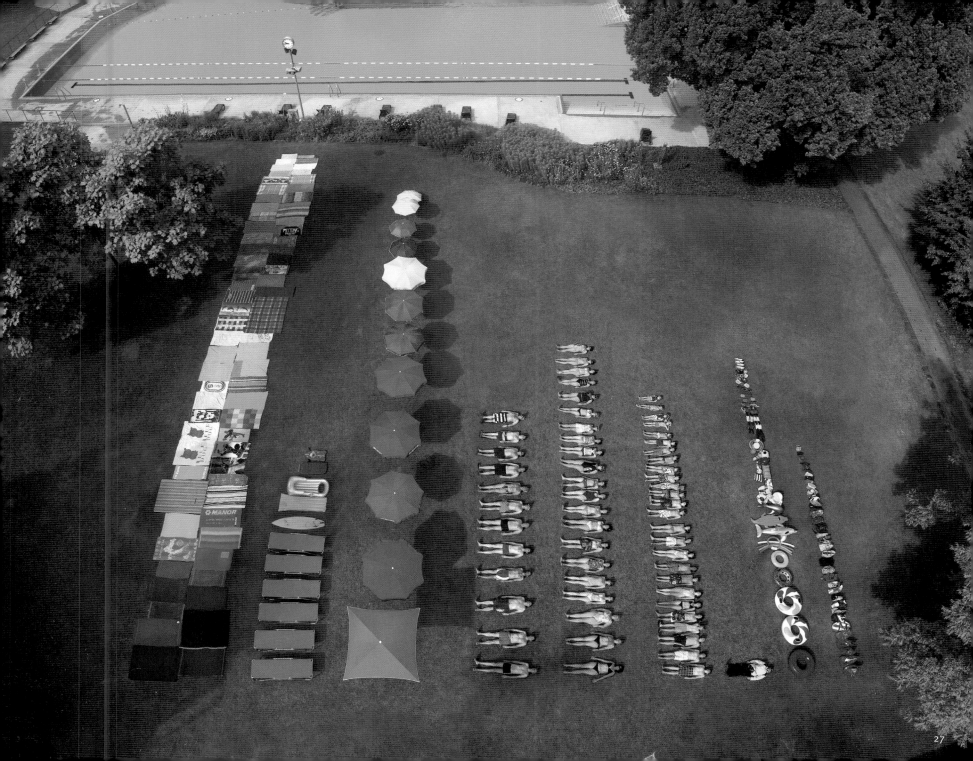

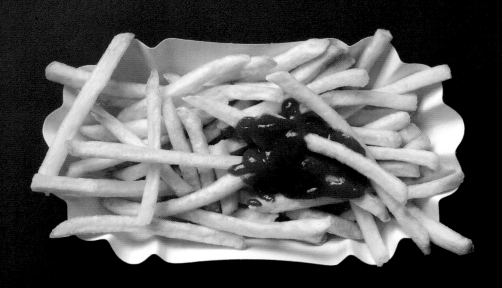

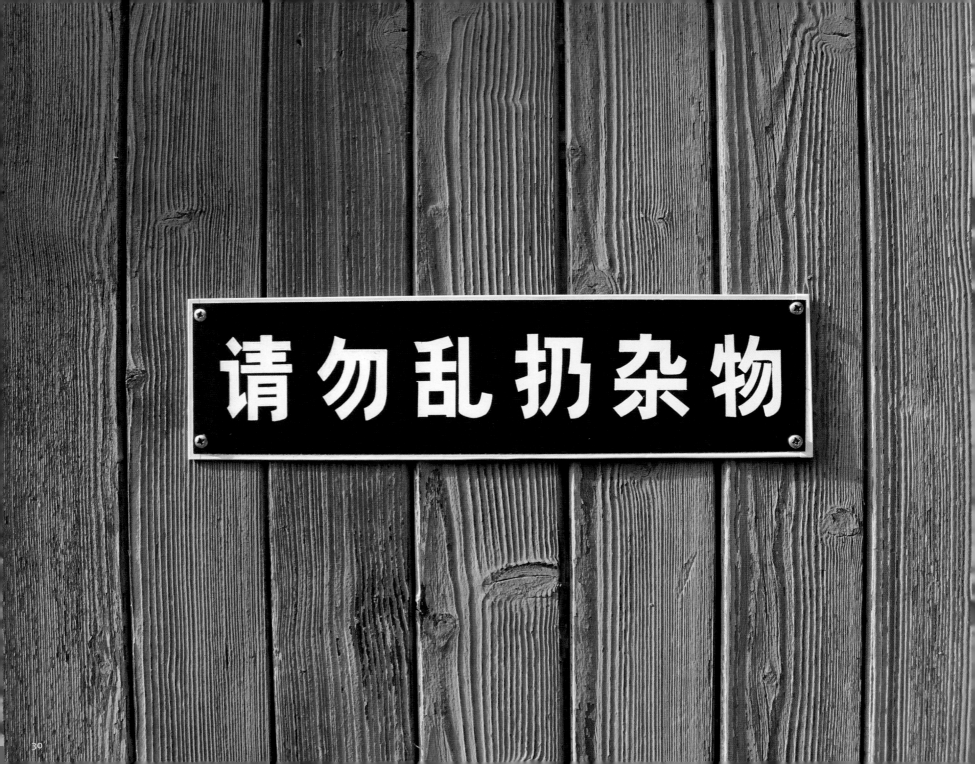

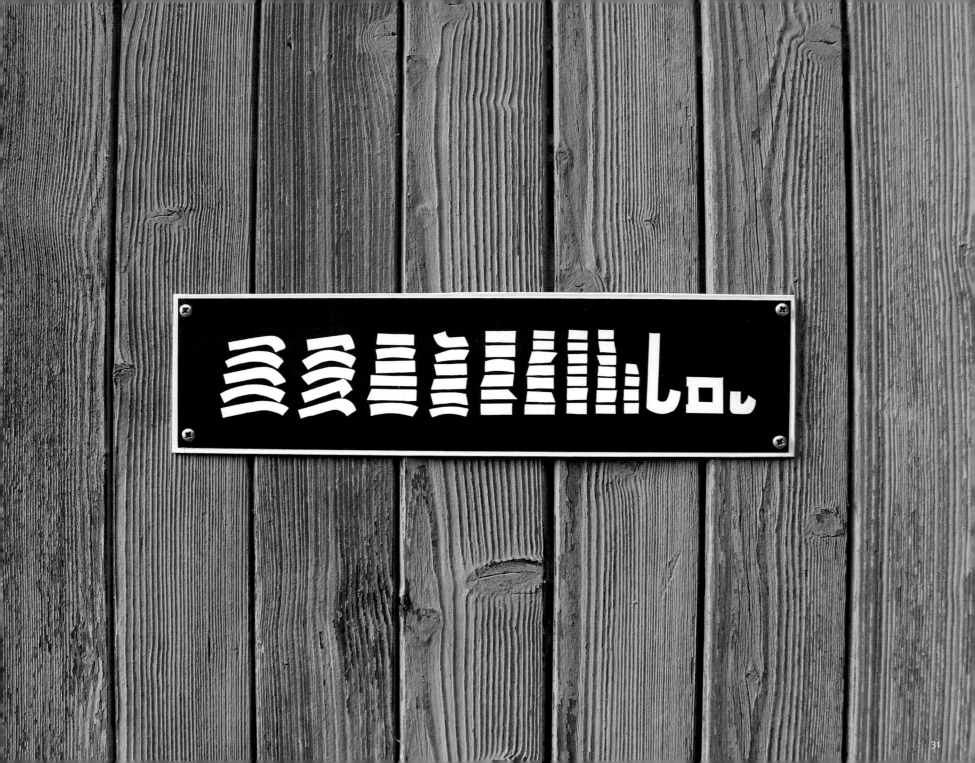

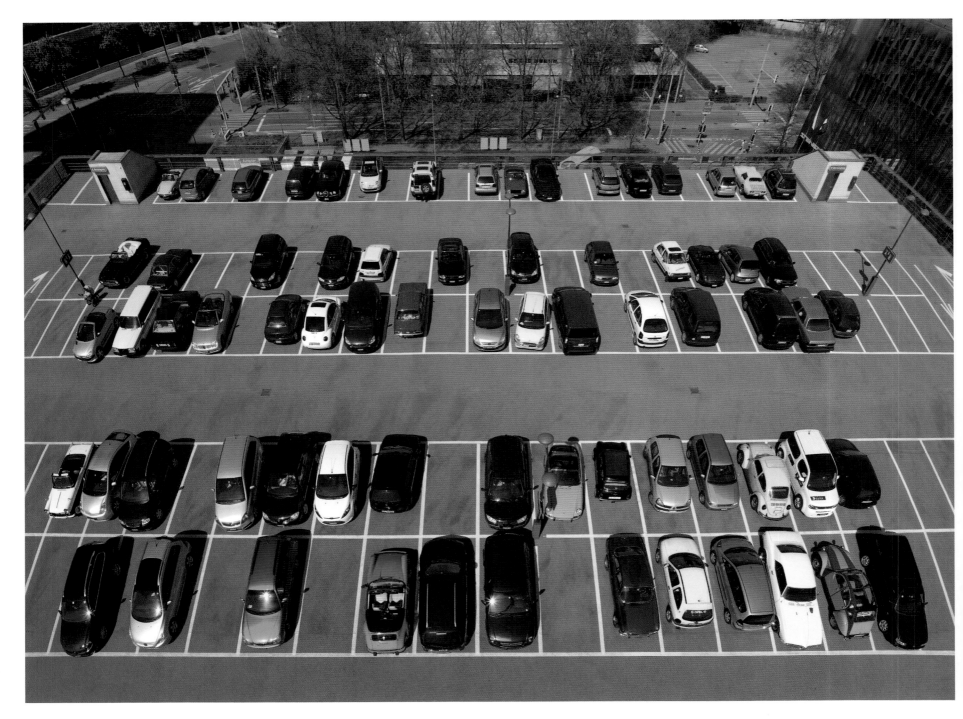

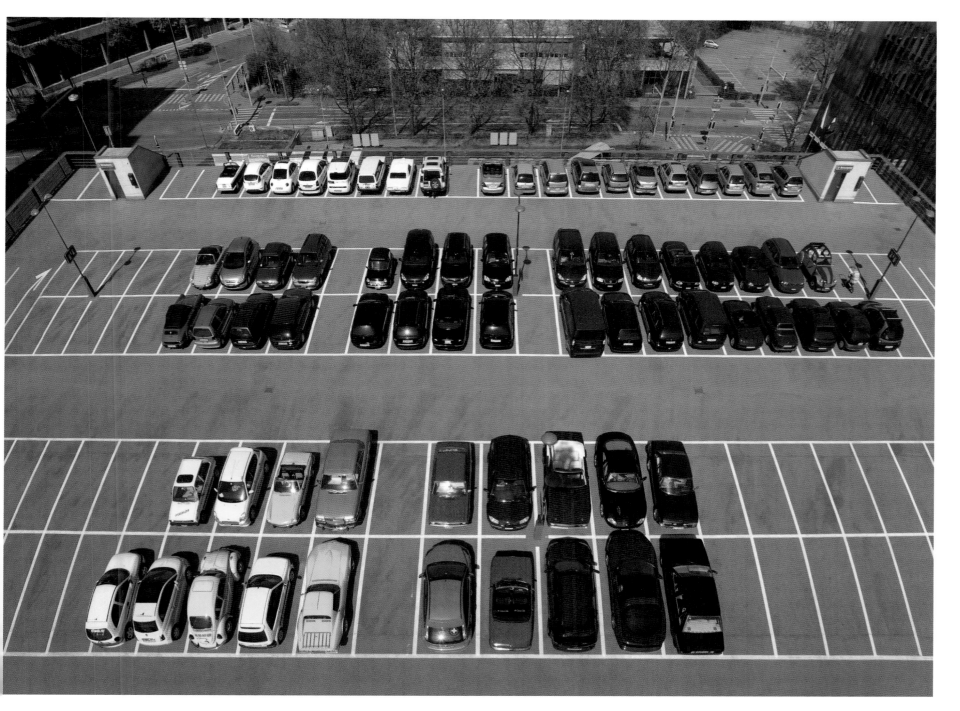

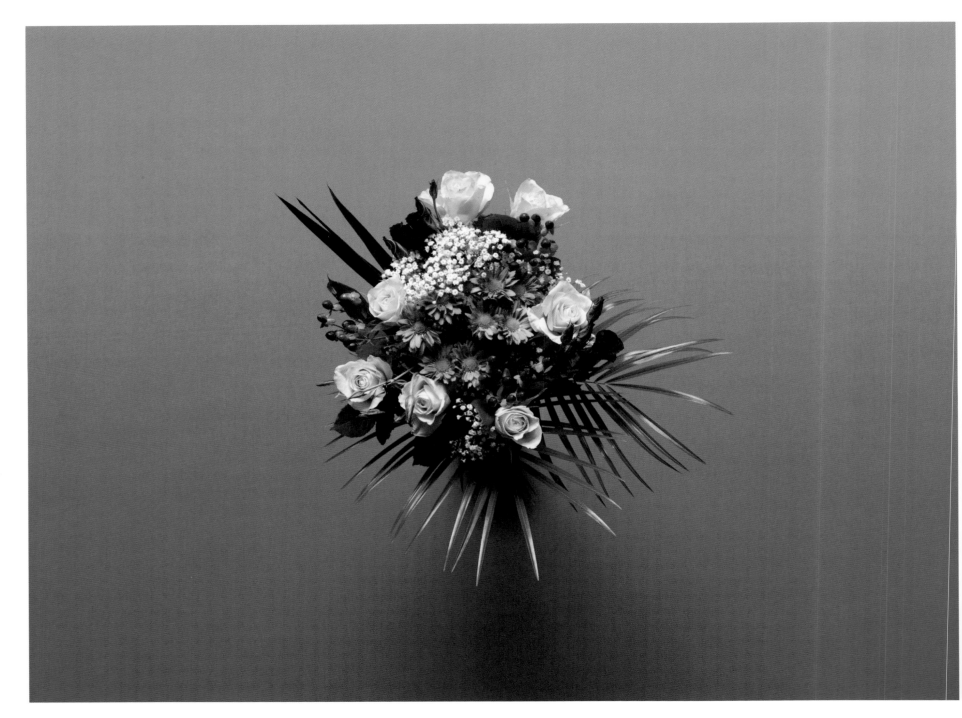

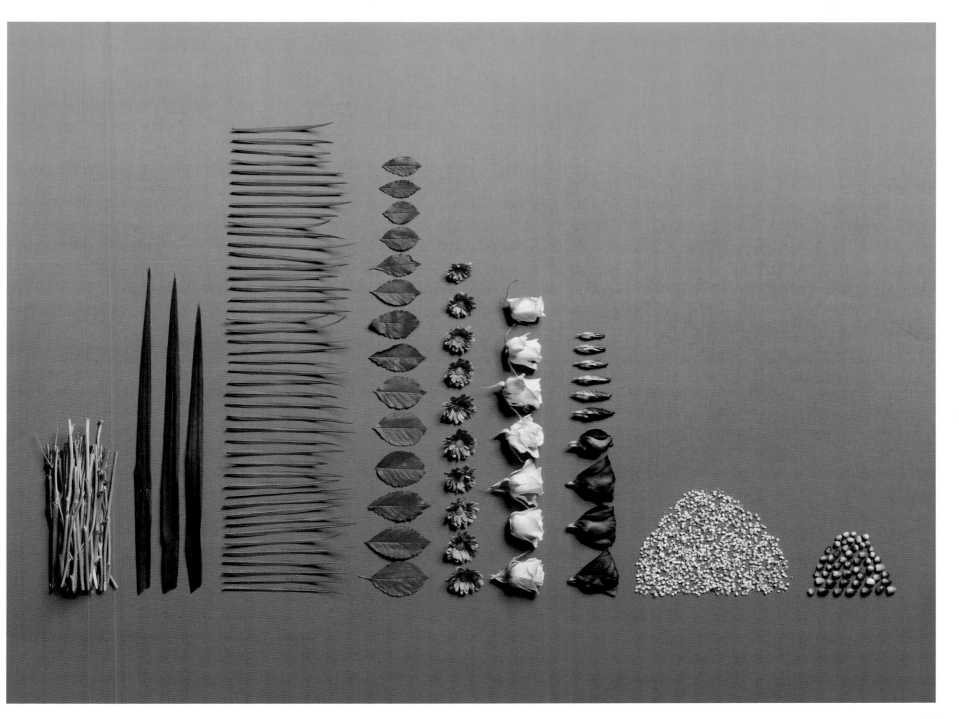

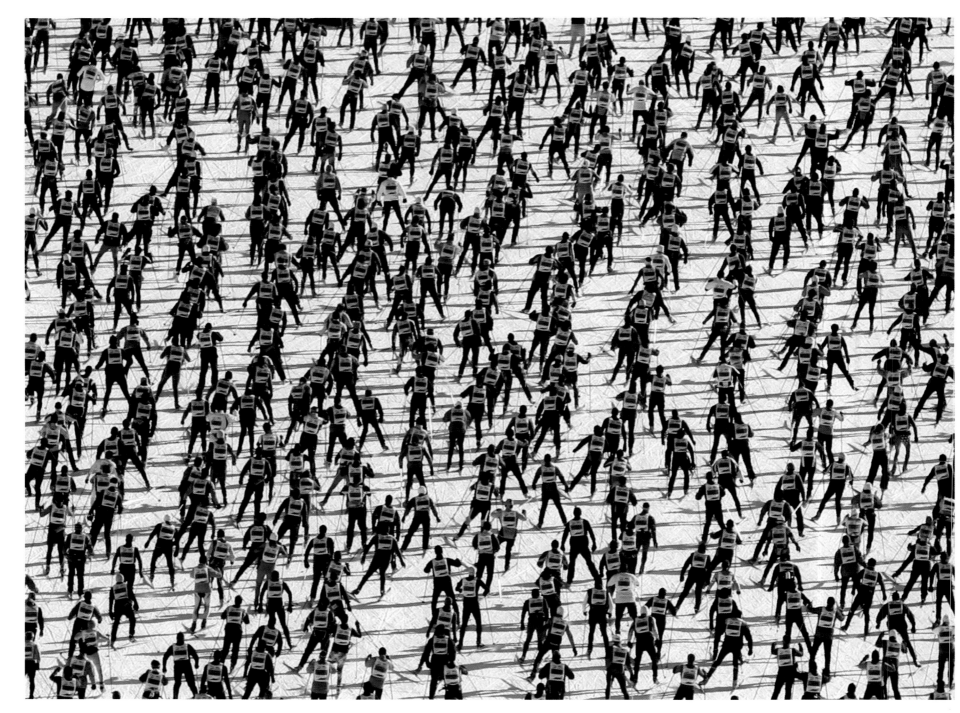

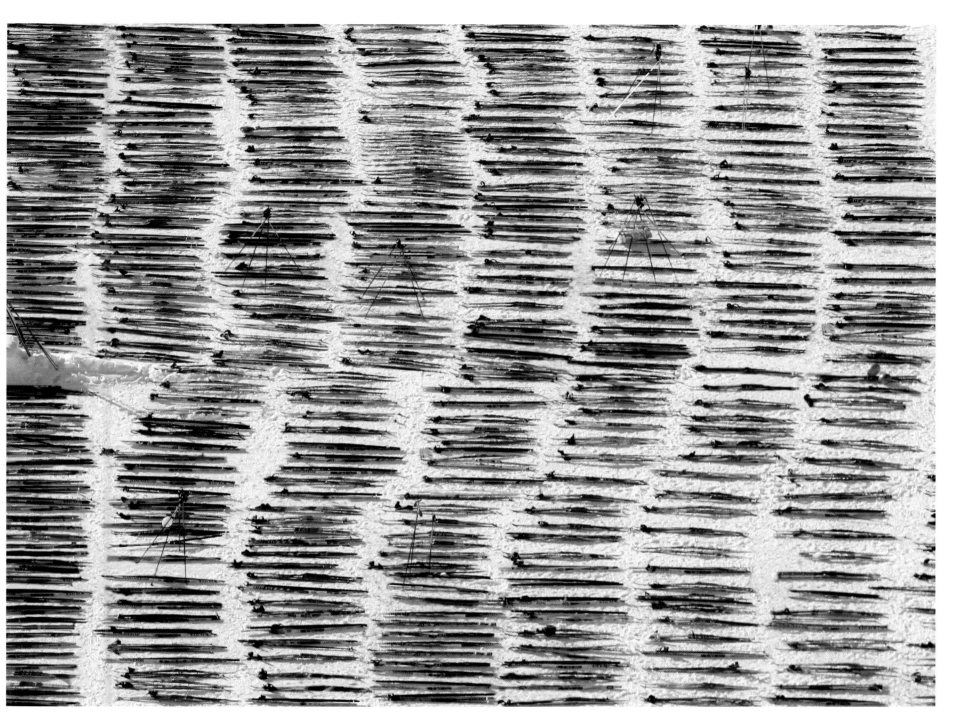

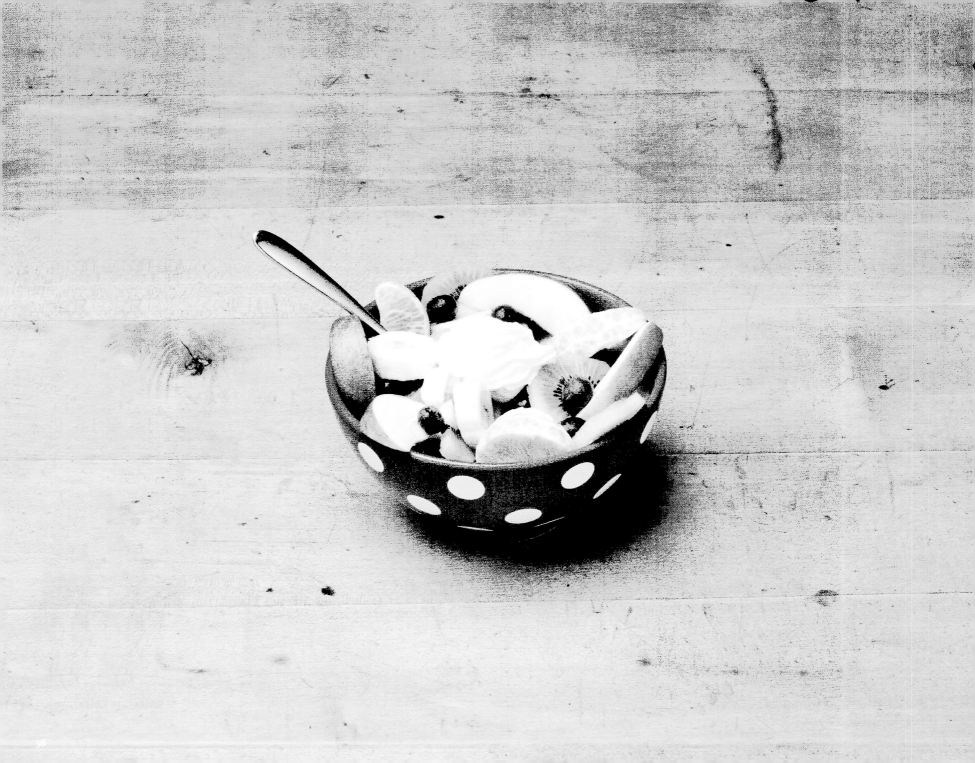

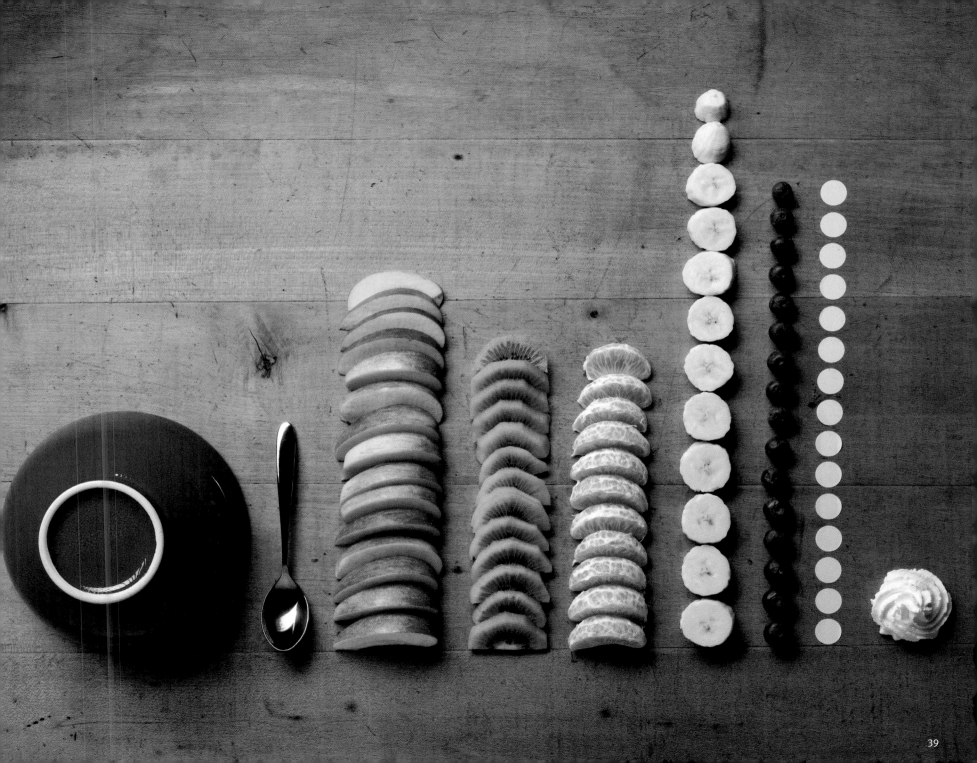

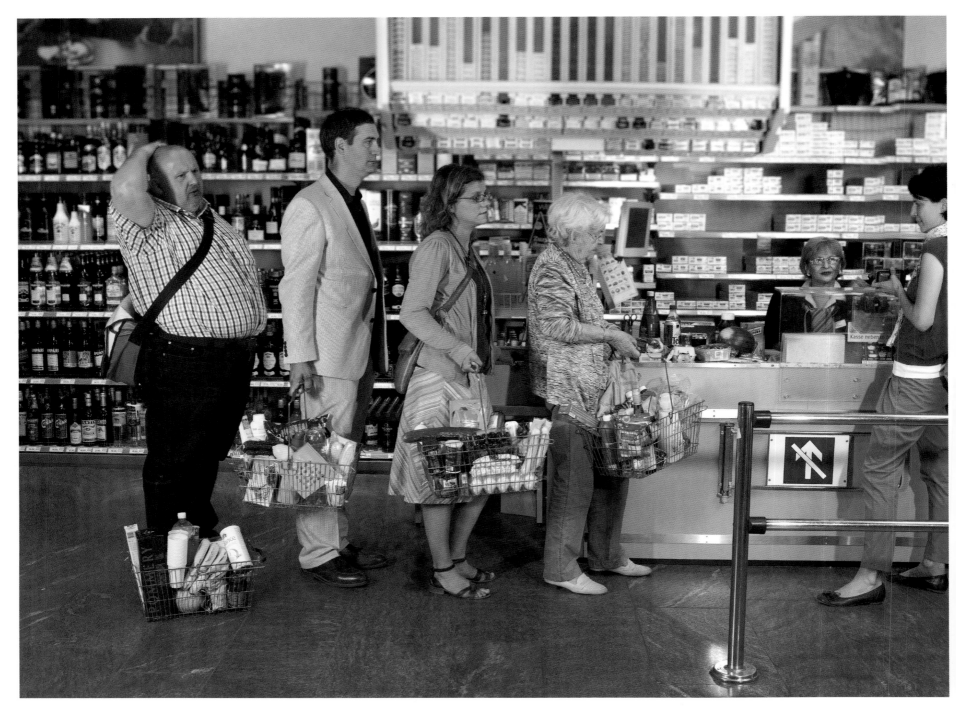

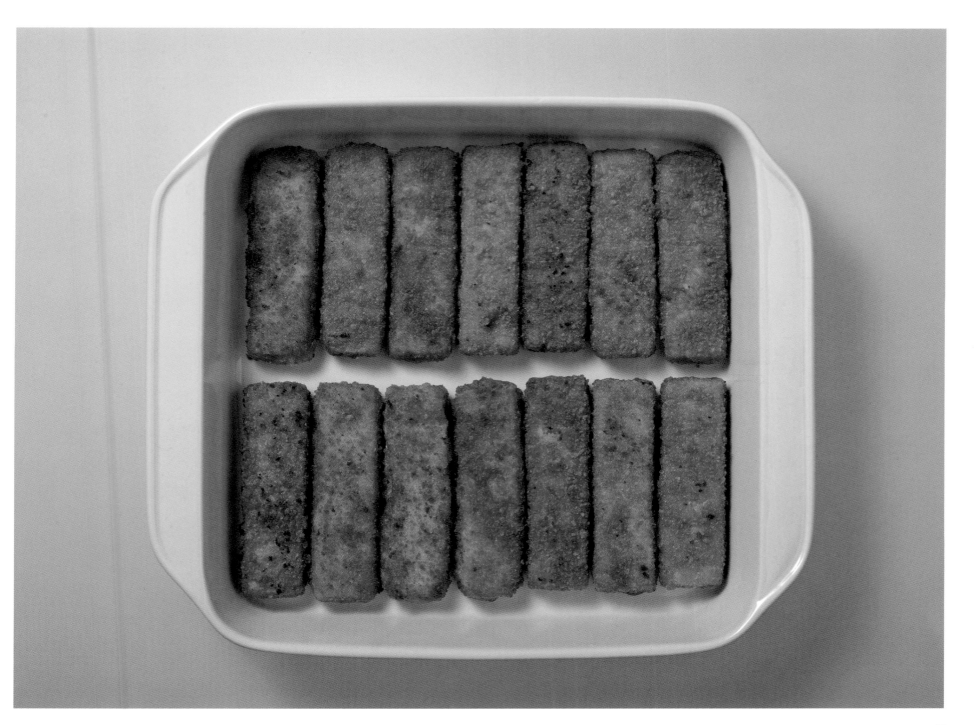

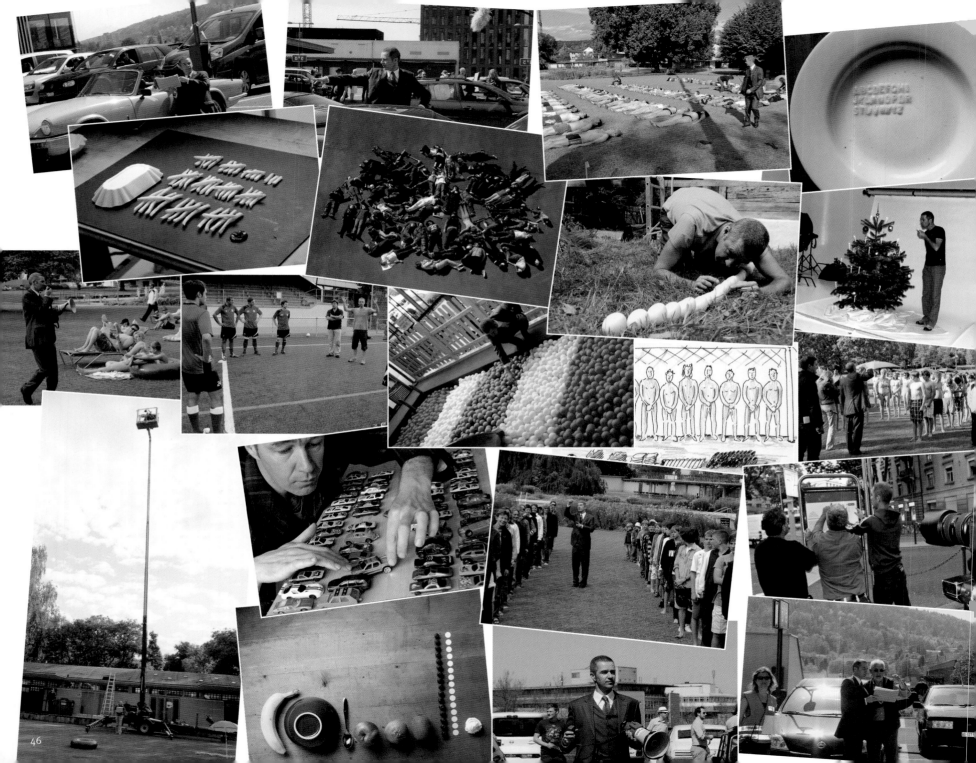

46

Ursus Wehrli is a left-handed, broad-thinking, professional typographer. His first book, *Tidying Up Art*, is a visionary manifesto that took well-known artworks and put them back together in his more rational, more organized, and cleaner form of modern art. In this book, *The Art of Clean Up*, Wehrli extended his discerning eye into the physical world to tidy up common daily situations. He is currently working on sorting things that are normally too big to organize.

Besides bringing order to environments and artwork, Wehrli has delighted audiences for over a quarter of a century with his comedy-duo Ursus & Nadeschkin, touring in Zurich, Berlin, London, Melbourne, and New York. The duo has won many awards including the Reinhart Ring and the New York Comedy Award, among others.

Ursus Wehrli lives in Zürich as a comedian, live performer, and freelance artist, and can be hired to perform to put things in (his) order.

www.uruswehrli.com

Ideas, themes, clean-up efforts: Ursus Wehrli
Production (outdoor shoots): HAISCH HUNTER GMBH
Project assistant: Patricia Umbricht
Camera assistance (outdoor shoots): Kathrin Schulthess
Camera and film direction: Marcel Weiss

The author would like to thank the following companies and institutions for their cooperation:
WS-Skyworker AG, SC Bümplitz 78, Bad Allenmoos, Parkhaus Messe Zürich AG, Freilichtmuseum Ballenberg, Verkehrskadetten department Zürcher-Unterland, Sportamt Zürich, Verkehrsbetriebe Zürich VBZ, COOP City, Primarschule Steiacher Brüttisellen, Universität Bonn, Tosoni-Metzg AG, Schellenberg & Schnoz Architekten AG, spoonfilm medienproduktion GmbH, Westdeutscher Rundfunk (WDR).

Thanks to the following people for their invaluable assistance:
Peter Haag, Sandra Rizzi, Stephan Haller, Nadja Sieger, Jörg Daiber, Beatrice Hirzel, Elisabetta Martinelli, Thom F. Küng, Werner Huggenberger, Tanja Giuliani, Martin Haemmerli, Mathis Füssler, Hansueli Flück, and Dr. Manuel Strasser. And Brigitta and Jodok!

The author would like to thank the Cassinelli-Vogel Foundation in Zürich for its kind support.

Cover image, endpapers: Geri Born
Additional photographs:
Geri Born (pages 4, 5, 6, 7, 10, 11, 14, 15, 16, 17, 24, 25, 28, 29, 38, 39, 43, 44, 45)
Daniel Spehr (pages 8, 9, 12, 13, 22, 23, 26, 27, 32, 33, 40, 41, 42, 43)
Florian Foest, spoonfilm, WDR (pages 20, 21, 47)
Steffen Schmidt, Keystone (pages 36, 37)
Shutterstock (page 42)
Data of the European Observatory (page 18)
Ursus Wehrli (pages 30, 31)

Library of Congress Cataloging-in-Publication Data available.

ISBN: 978-1-4521-1416-3

Manufactured in North America

Cover design by Kristen Hewitt
Design of the original edition by Sandra Rizzi

10 9 8 7 6 5 4

Chronicle Books LLC
680 Second Street
San Francisco, CA 94107

www.chroniclebooks.com

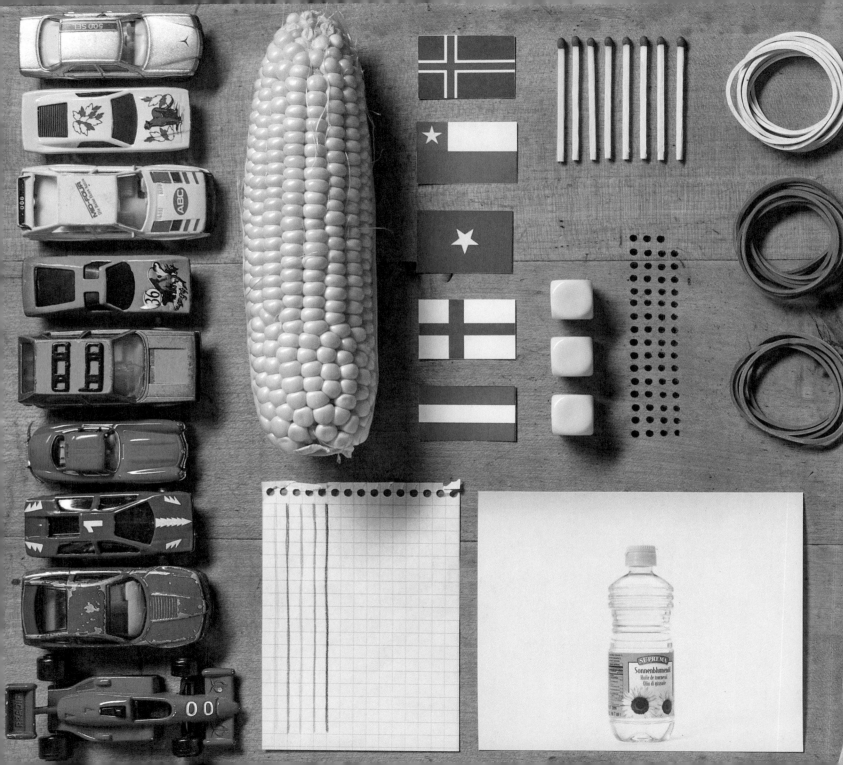